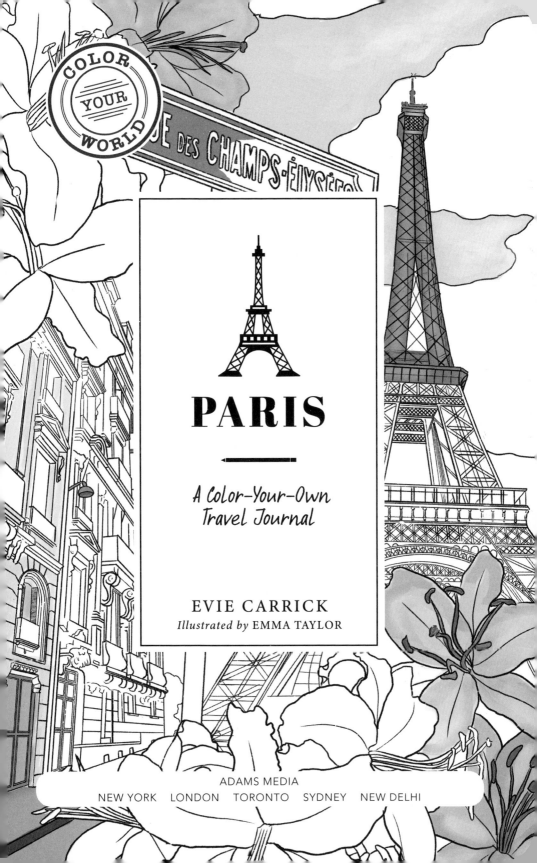

PARIS

A Color-Your-Own Travel Journal

EVIE CARRICK

Illustrated by EMMA TAYLOR

ADAMS MEDIA

NEW YORK LONDON TORONTO SYDNEY NEW DELHI

Adams Media
An Imprint of Simon & Schuster, Inc.
100 Technology Center Drive
Stoughton, Massachusetts 02072

First Adams Media trade paperback edition November 2023

ADAMS MEDIA and colophon are registered trademarks of Simon & Schuster, Inc.

For information about special discounts for bulk purchases, please contact Simon & Schuster Special Sales at 1-866-506-1949 or business@simonandschuster.com.

The Simon & Schuster Speakers Bureau can bring authors to your live event. For more information or to book an event, contact the Simon & Schuster Speakers Bureau at 1-866-248-3049 or visit our website at www.simonspeakers.com.

Interior design by Michelle Kelly
Illustrations by Emma Taylor
Interior images © 123RF

Manufactured in China

10 9 8 7 6 5 4 3 2 1

ISBN 978-1-5072-2148-8

Contents

Introduction

From the Eiffel Tower to the Louvre to lesser-known locales like the Grande Mosquée de Paris, the city of Paris is one of the world's most visited cities—and for good reason. Whether you see them in person or just imagine visiting, the lush gardens, multicolored macarons, and elegant buildings lend themselves to coloring pages that you can fill in as creatively as you'd like.

This guided coloring journal highlights the very best of Paris, and is perfect for travelers of all kinds—from repeat visitors to those who prefer to daydream from afar. Add your own color to the lovely Sacré-Cœur Basilica, the iconic Moulin Rouge, or the elaborate gardens of Château de Versailles—whether on the plane to France or from the comfort of your own home. You can also read fascinating background information about each of the thirty sites (arranged in order of their numbered *arrondissements*, or neighborhood), along with insider tidbits that will make you feel like a real Parisian. Use the journal space provided with each site to record any notes or research you do, to recall your experiences during your visit there, or to simply write down your thoughts about each incredible place.

Whether this book serves as a travel guide for your next trip to Paris, rekindles memories of a past visit, or provides an escape from your everyday life, let *Color Your World: Paris* whisk you away to the unforgettable City of Lights. Grab your pen and colored pencils, awaken your adventurous spirit, and relish Paris's unique *joie de vivre*.

Musée du Louvre

Rue de Rivoli,
75001 Paris, France
Est. 1793

The Louvre is the most visited museum in the world, and for good reason. The 652,300-square-foot art museum, which used to be a palace, sits in the center of Paris and is home to some of the world's best-known works of art, including the *Mona Lisa* and the ancient Greek sculpture *Venus de Milo*. The museum houses many magnificent but lesser-known exhibits as well. In the Sully Wing, you can meander through two floors of Egyptian antiquities before descending underground to see the Histoire du Louvre collection, which showcases the remains of the medieval Louvre Castle the museum was built upon.

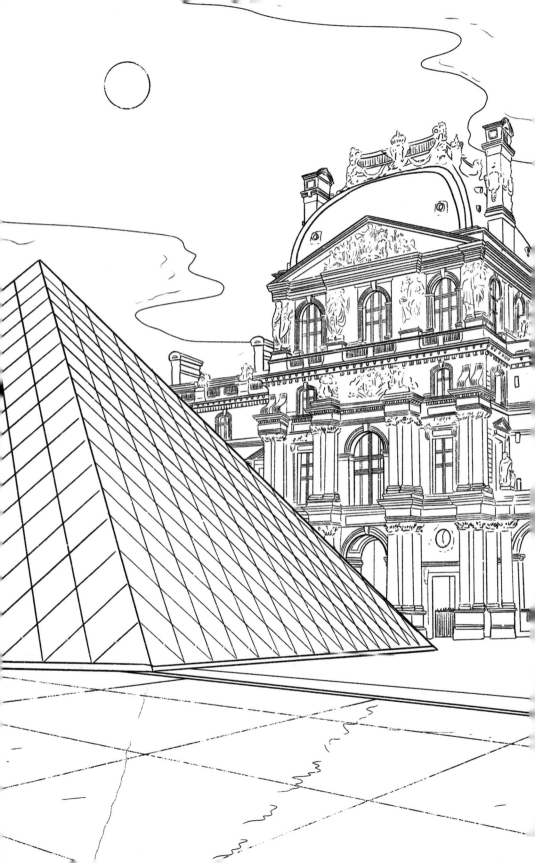

Jardin des Tuileries

..

Tuileries Garden

Place de la Concorde,

75001 Paris, France

Est. 1564

The Jardin des Tuileries is the perfect complement to a day spent in the bustling Louvre Museum next door. As you pass through the marble archway that separates the two sites, you'll find yourself in a statue-studded seventeenth-century garden dotted with Paris's iconic green lounge chairs. What better place to watch the ducks play in the fountains or enjoy some of the city's best people-watching? In the summer, adventurers head to Fête des Tuileries for a Parisian fair experience—complete with trampolines, a Ferris wheel, and a giant slide.

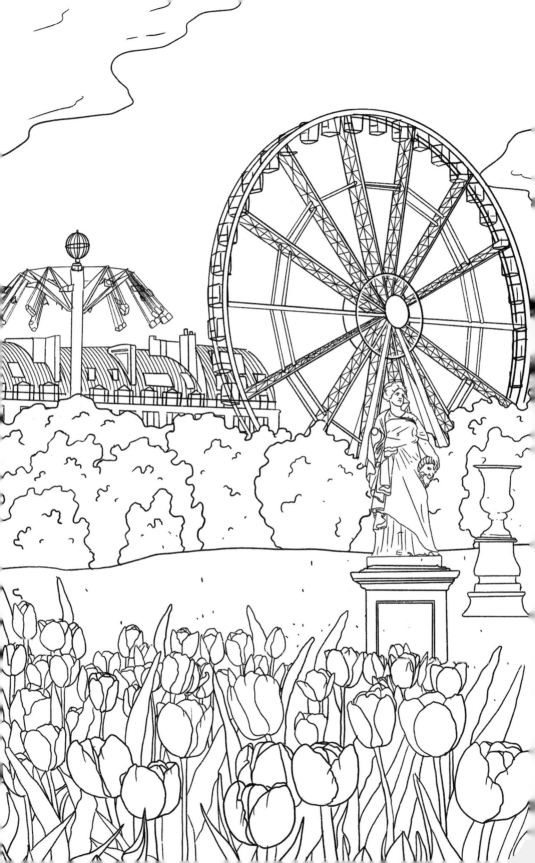

Galerie Vivienne

4 Rue des Petits Champs,
75002 Paris, France
Est. 1823

One of the most magical things about Paris is the series of covered passages that quietly meander off busy city streets, transporting people into another world. It is estimated that there are around twenty covered passages near the 2nd arrondissement, with each having its own appeal. Galerie Vivienne, which has been a registered historical monument since 1974, is one of the most iconic. The floors are covered with colorful mosaics and the glass roof lets in plenty of natural light. Tearooms, restaurants, bookshops, and clothing boutiques line the over five-hundred-foot-long passage that travels into the heart of the city.

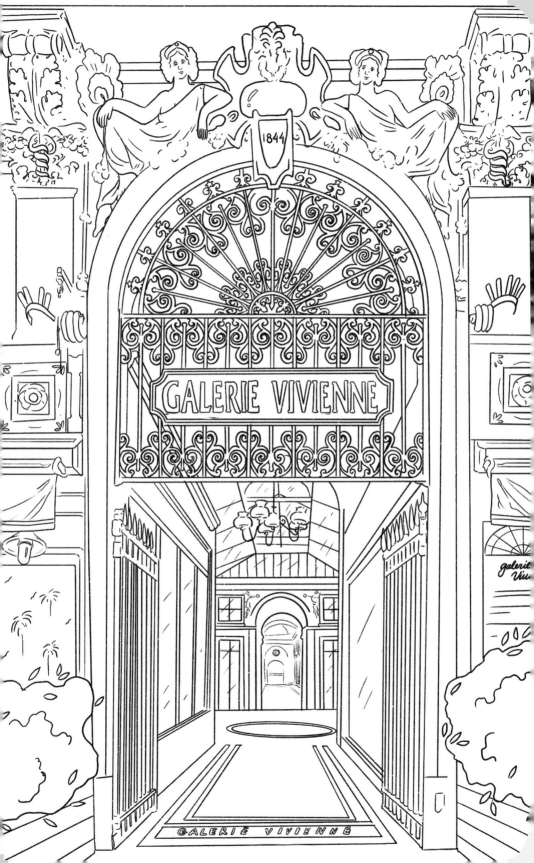

Marché des Enfants Rouges

..

Market of the Red Children

39 Rue de Bretagne,

75003 Paris, France

Est. 1615

This covered outdoor market dates back to the seventeenth century, when Parisians came to purchase their weekly haul of fruits and vegetables. "Marché des Enfants Rouges," which translates to "Market of the Red Children," was named for the red-clothed orphans (a sign of Christian charity) who once occupied the neighboring orphanage and hospital. More than four hundred years later, the market still has stalls of fresh fruits, vegetables, and flowers, but its biggest draw is the handful of eateries that have set up shop inside. You can eat at one of the restaurant tables or grab your food to go and savor it on a park bench in the Square du Temple across the street. Nowadays, local artists also sell their wares—jewelry, gifts, and leather goods—outside the market.

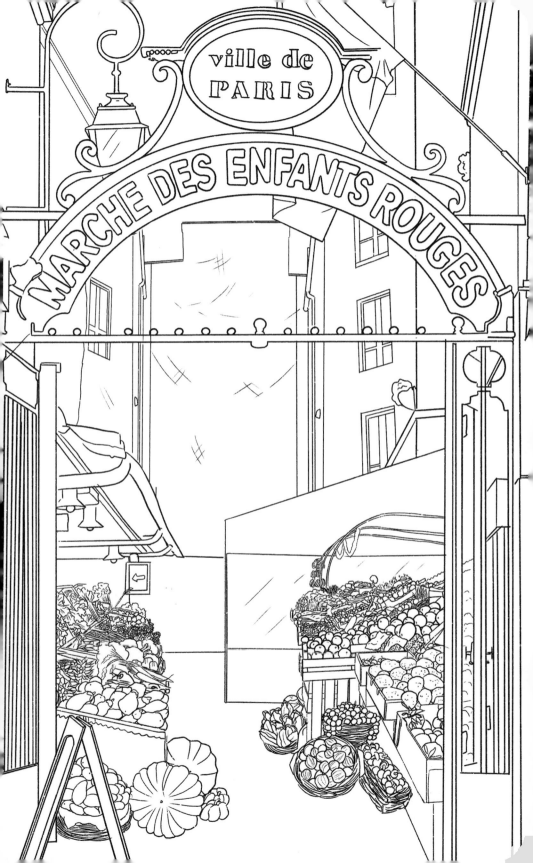

Cathédrale Notre-Dame de Paris

Notre-Dame Cathedral

6 Parvis Notre-Dame–Place Jean-Paul II,

75004 Paris, France

Est. 1345

The medieval Catholic cathedral Notre-Dame sits prominently on the Île de la Cité, the island in the Seine where Paris got its start. From its water-bound perch, the Right Bank sprawls to the north and the Left Bank to the south. The building, which sustained a fire in April 2019, is considered to be one of the finest examples of French Gothic architecture in the world. The cathedral was constructed between 1163 and 1345 and has a stunning exterior with two bell towers and a facade that's covered with stone gargoyles. The building is also the site of Victor Hugo's novel *The Hunchback of Notre-Dame*, which has been adapted several times for the stage and screen.

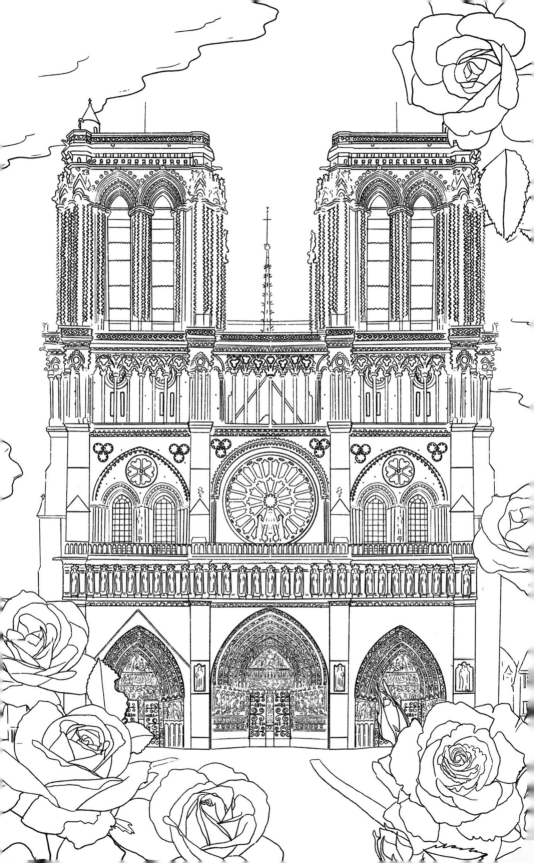

Marché aux Fleurs

..

Marché aux Fleurs Reine-Elizabeth-II
(Flower Market of Queen Elizabeth II)

37 Place Louis Lépine,

75004 Paris, France

Est. 1808

The Marché aux Fleurs is a flower market that sits in the historic heart of Paris on the same island that boasts Notre-Dame. A paradise for those searching out greenery, flowers, and fresh air in the center of the city, it was originally named Marché aux Fleurs et aux Oiseaux Cité (which translate to "Flower Market and Bird City"), before being renamed the Marché aux Fleurs Reine-Elizabeth-II after Queen Elizabeth II's visit in 2014. When you're walking through the open-air flower stalls and the delightfully perfumed covered market, you'll feel miles away from the bustle of the city. The Marché aux Fleurs has been a gardener's go-to since 1808 and remains a Parisian staple for those in search of local seasonal blooms, exotic flowers, and potted plants and shrubs.

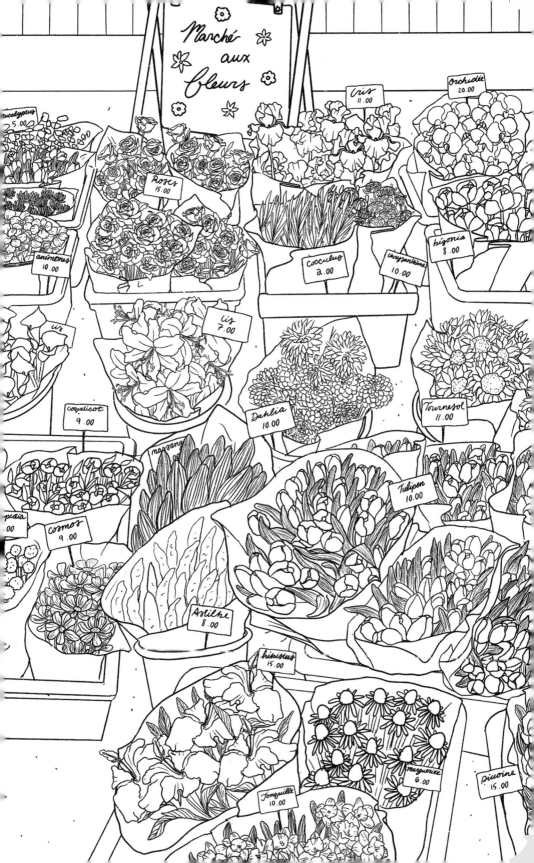

Centre Pompidou

..

Centre National d'Art et de Culture Georges-Pompidou (Pompidou Centre)

Place Georges-Pompidou,

75004 Paris, France

Est. 1977

It's almost impossible to miss the Centre Pompidou, which is a stark contrast to most of the city's buildings. The colorful "inside-out" structure has an industrial air about it, with the structural, mechanical, and circulation systems exposed on the exterior of the building. But whether you love the building or hate it, no one can deny the thrill of riding the escalator—which is surrounded by glass and travels up the outside of the building—to the top. The gradual unfolding of city views culminates with the great reveal at the top, where most of Paris's major sites—including Notre-Dame and the Eiffel Tower—can be seen. Inside is a public library and an art museum, where visitors are treated to the largest modern art collection in Europe, including masterpieces by Frida Kahlo, Henri Matisse, and Marc Chagall.

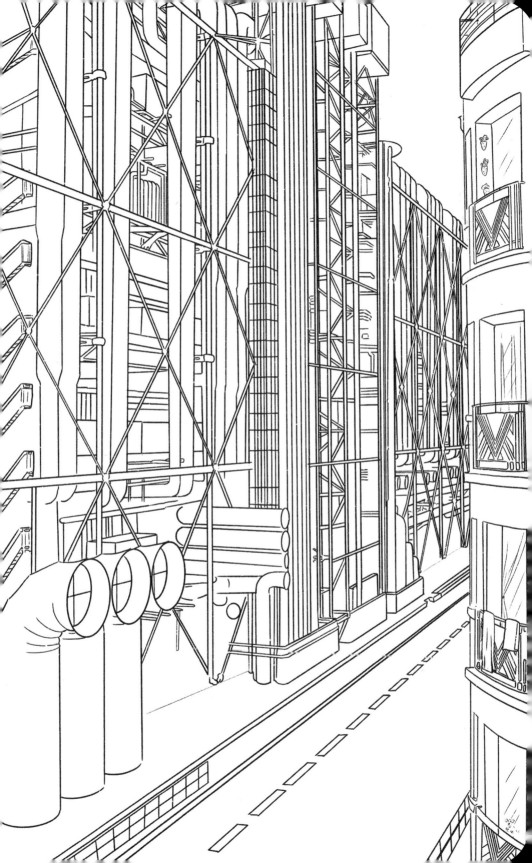

Shakespeare and Company

37 Rue de la Bûcherie,
75005 Paris, France
Est. 1951

This English-language bookstore has long been a haven for English speakers in Paris. Its location across from Notre-Dame is only topped by the treasures it houses: two floors of books, plenty of cozy reading nooks, and a resident cat named Aggie who patrols the building. The bookstore was opened in 1951 by George Whitman, an American who lived most of his life in Paris and was known for letting travelers—often artists and writers—stay in the shop in exchange for help around the store. Shakespeare and Company independently published James Joyce's *Ulysses* when no other publisher would, and the store welcomed such famous names as Ernest Hemingway, F. Scott Fitzgerald, James Baldwin, Gertrude Stein, Allen Ginsberg, Henry Miller, and many others.

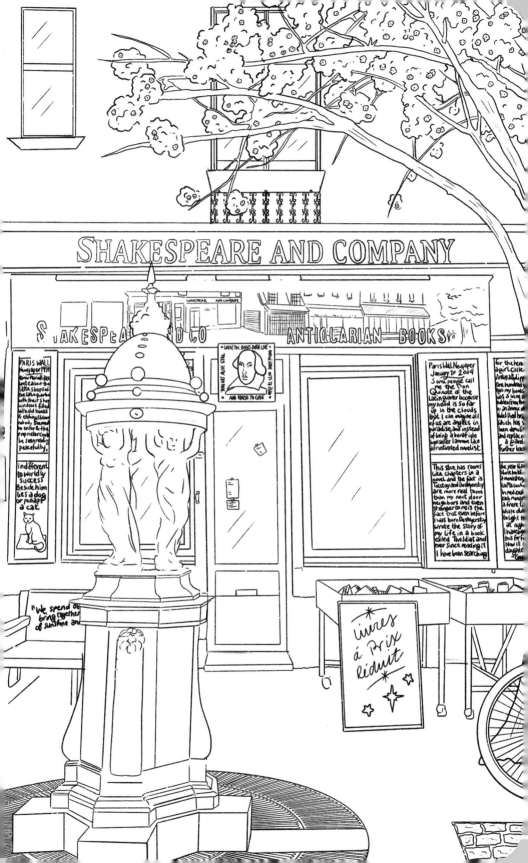

Grande Mosquée de Paris

..

Great Mosque of Paris

2bis Place du Puits de l'Ermite,

75005 Paris, France

Est. 1926

The Grande Mosquée de Paris is an important religious gathering place for Muslims in Paris, and parts of it are open to tourists as well. From the outside, the mosque is impressive, with a 108-foot minaret, towering white walls, and eye-catching turquoise accents. Inside, there are prayer rooms, a lush courtyard garden filled with blooms, beautiful mosaic tiling, and a tearoom serving up traditional mint tea and plates piled high with *baklava*, *makroud*, and *m'hanncha*. The mosque's open-air terrace is surrounded by greenery and flowers and shaded by trees. The Grande Mosquée de Paris also has a full-service restaurant and a *hammam* (steam bath).

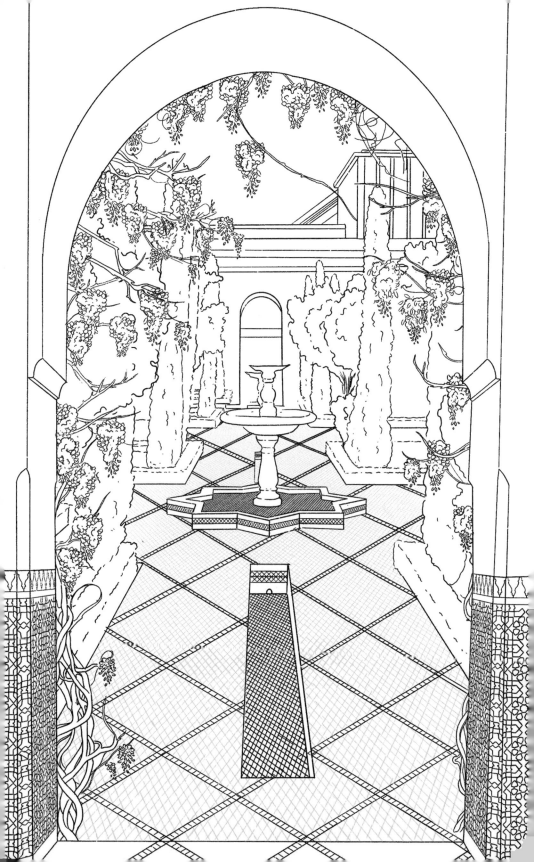

Les Deux Magots

Two Chinese Figurines

6 Place Saint-Germain des Prés,

75006 Paris, France

Est. 1812

For more than a century, Les Deux Magots has been a gathering place for artists and intellectuals. The café, which opened in 1885 (it originally opened in 1812 as a novelty shop), has welcomed the likes of Richard Wright, Albert Camus, Pablo Picasso, and Julia Child over the years. Its reputation has earned it a place in various movies, TV shows, and pieces of literature. Modern-day actors, artists, and politicians can still be spotted at Les Deux Magots from time to time—but these days, it's filled with more tourists than celebrities. Sitting at Les Deux Magots's iconic corner café tables, enjoying a cup of their rich, ultra-thick hot chocolate while people-watching, is a quintessential Parisian experience.

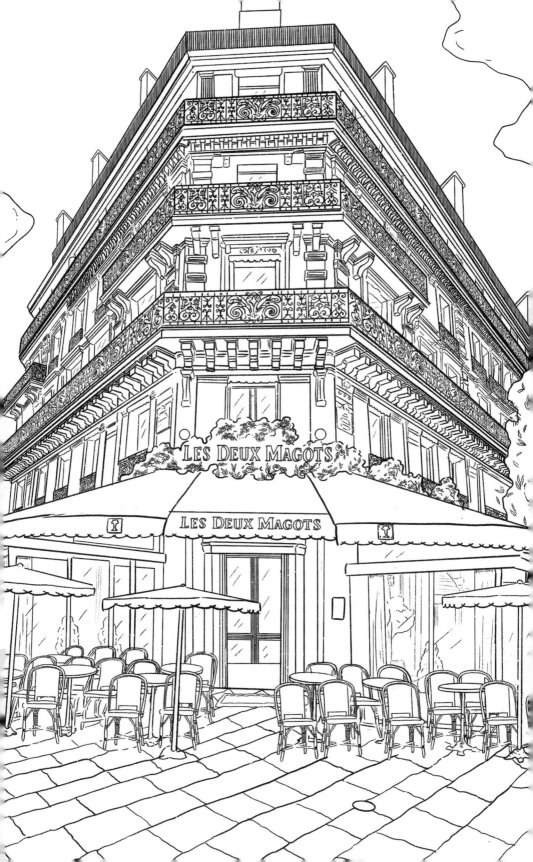

La Tour Eiffel

..

Eiffel Tower

Champ de Mars, 5 Ave. Anatole France,

75007 Paris, France

Est. 1889

The Eiffel Tower has become synonymous with the capital city. The iconic landmark is perched on the bank of the Seine and reaches 1,083 feet in height, allowing many travelers to catch a glimpse of the site before their plane even lands in Paris. The tower, which was constructed for the 1889 World's Fair, was named after Gustave Eiffel, a French engineer who designed the tower not long after building the framework for the Statue of Liberty. If you're able to visit, there's nothing like enjoying a baguette, cheese, and a sparkling beverage from the tree-lined green space that sits at the foot of the tower. From there, the views are unobstructed and the true size of the tower can be felt. If you're interested in city views, buy a ticket to the top. To the east on a clear day, you'll get a bird's-eye view of many iconic landmarks, including the Louvre, Notre-Dame, Grand Palais, and Sacré-Cœur.

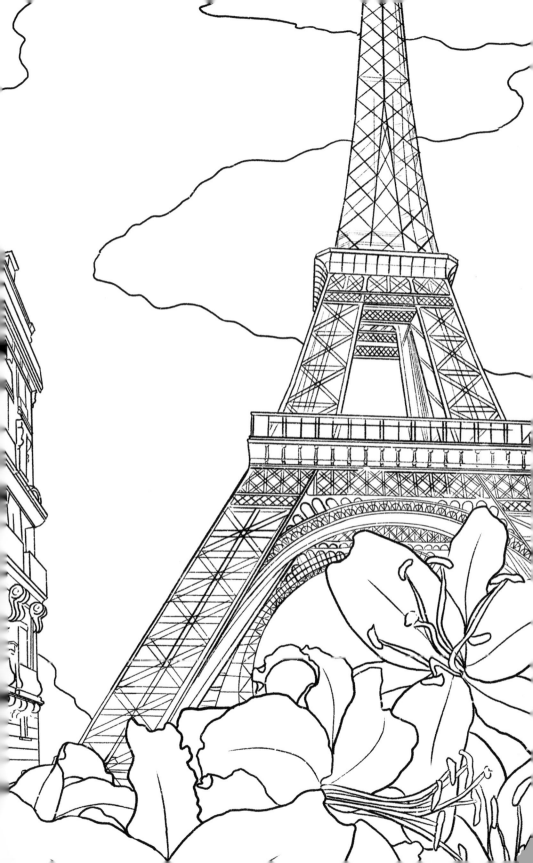

Musée d'Orsay

Orsay Museum

1 Rue de la Légion d'Honneur,

75007 Paris, France

Building est. 1900; museum est. 1986

Perched on the Left Bank of the Seine, directly across from the Jardin des Tuileries and the Louvre, is one of Paris's most beautiful structures. The waterfront Beaux Arts building was originally built to be a railway station, but instead served as a mail center and film set before being transformed into the Musée d'Orsay in 1986. The original purpose of the building is still apparent, especially inside where the all-glass roof (common among European train stations) and towering Musée d'Orsay clock can be seen. And while the building itself is incredible, the art it holds has made it one of the most visited art museums in the world. There are multiple collections showcasing furniture to photography, but the museum is best known for its collection of French art, including paintings by Paul Cézanne, Claude Monet, and Pierre-Auguste Renoir.

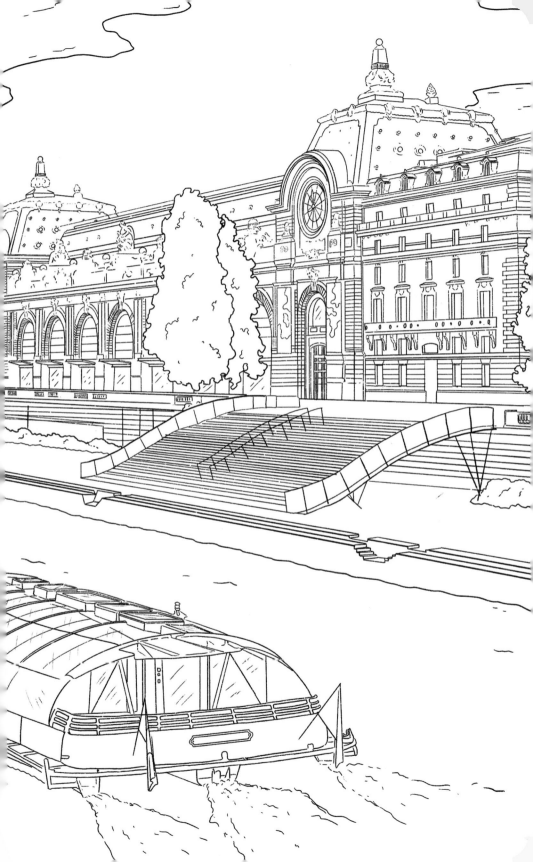

Fromagerie Quatrehomme

Quatrehomme Cheese Shop

62 Rue de Sèvres,

75007 Paris, France

Est. 1953

This cheese shop, which got its start in 1953, has made a name for itself among tourists and Parisians alike. Its preeminence was confirmed in 2000, when owner Marie Quatrehomme was named one of the "Meilleur Ouvrier de France Fromager" (best cheese craftsperson in France)—making her the first woman to receive the esteemed title. The shop in the 7th arrondissement always has between two hundred and two hundred fifty different cheeses available, including a handful of popular specialty items, like a Burgundy cheese accented with Japanese whiskey or a soft Saint-Marcellin cheese coated with roasted almonds, lemon, and honey.

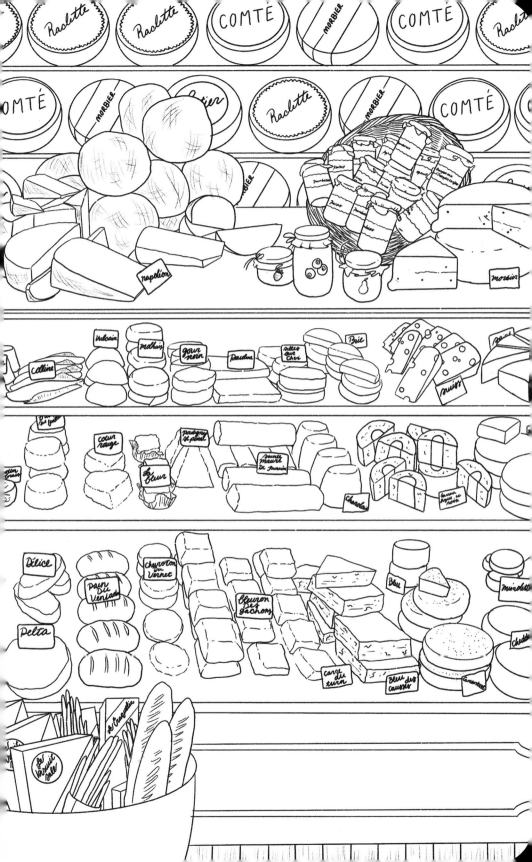

Arc de Triomphe

..

Arc de Triomphe de l'Étoile
(Triumphal Arch of the Star)

Place Charles de Gaulle,

75008 Paris, France

Est. 1836

Twelve Parisian avenues radiate out from the Arc de Triomphe, which stands at the western end of the Champs-Élysées. Beyond acting as a hub for some of Paris's main thoroughfares, the arch is also a central component in the city's *Axe historique* (historic axis), a line of monuments that run from the Louvre in central Paris to the Grande Arche in the La Défense neighborhood west of the city. The arch was first commissioned by Napoleon following a victory in the Napoleonic Wars but was not completed until almost thirty years later. Not long after its completion, the body of Napoleon was carried under the arch en route to his final resting place at Les Invalides. Today, the panoramic terrace at the top of the Arc de Triomphe provides a bird's-eye view of the Champs-Élysées and a peek at of some of Paris's most beloved sites. Below the arch sits the Tomb of the Unknown Soldier, which honors an unidentified member of the French armed forces who was killed during World War I and symbolically commemorates every soldier who has died for France. Every evening the tomb's eternal flame is rekindled.

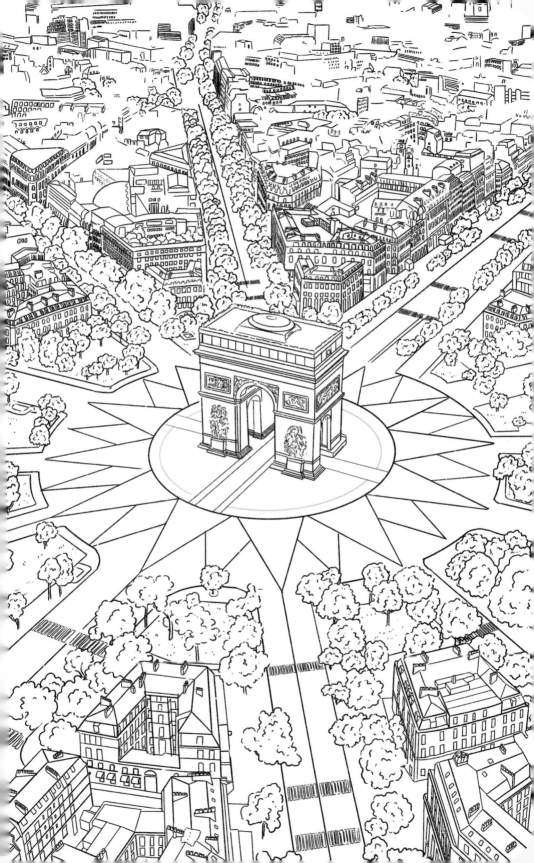

Champs-Élysées

Elysian Fields

In the 8th arrondissement between
the Place de la Concorde and the Place Charles de Gaulle

Est. 1667

The Champs-Élysées is easily the world's most iconic avenue. The mile-long stretch connects the Place de la Concorde, a major public square, and the Arc de Triomphe, and is bordered with high-end shops (think Dior and Louis Vuitton), beautiful theaters and hotels, and a flurry of cafés. You'll also find the extraordinary macarons and chocolates of Pierre Hermé, a French pastry chef and chocolatier, on this street. The avenue is best experienced on the one Sunday a month when it is free of cars, and pedestrians can waltz across the 230-foot-wide street for selfies in front of the Arc de Triomphe.

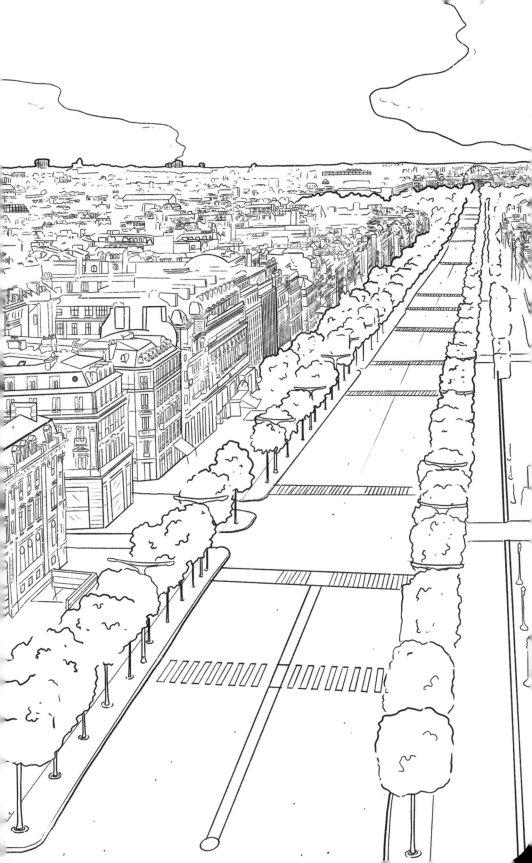

Ladurée

75 Ave. des Champs-Élysées,
75008 Paris, France
Original tearoom est. 1862

It's safe to say that Ladurée, an upscale bakery and tearoom that specializes in macarons, has become a Parisian institution. Their pale green boxes stuffed with colorful macarons seem to be everywhere—which explains the line out the door at any of their Paris locations. The popularity is well deserved, as the Ladurée family opened the first French tearoom *and* came up with the idea for a macaron in 1930. There are several locations in Paris, but it's hard to top the grand tea salon on the Champs-Élysées.

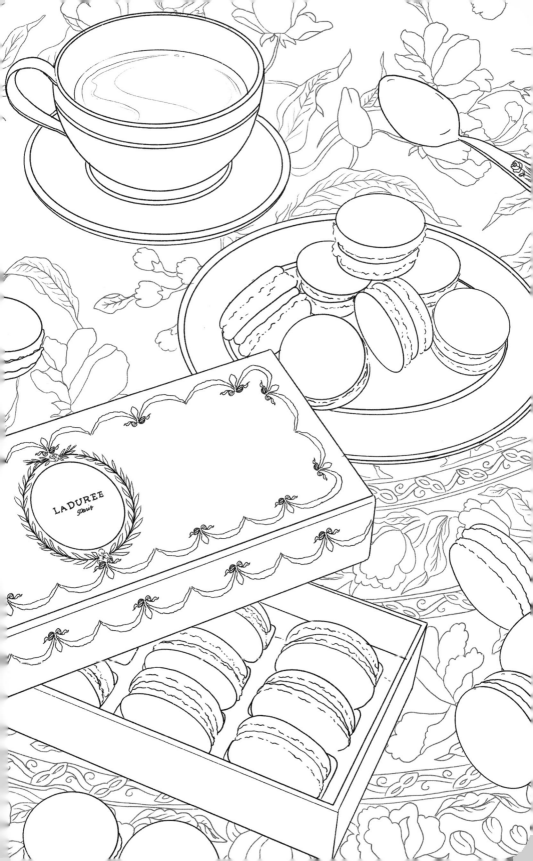

Palais Garnier (Opéra Garnier)

Garnier Palace

Place de l'Opéra,

75009 Paris, France

Est. 1875

The Palais Garnier, also known as Opéra Garnier, is much more than an opera house. The building, which was designed and built for the Paris Opera in the nineteenth century (at the request of Napoleon III), also houses a library and a museum that help conserve three centuries of the theater's history. Visitors can book a guided or self-guided tour of the building. Or they can go see a show; the experience of watching an opera here is second to none. The Grand Escalier, a double staircase made of marble, and the massive eight-ton crystal chandelier above the stage are as magical as the performances.

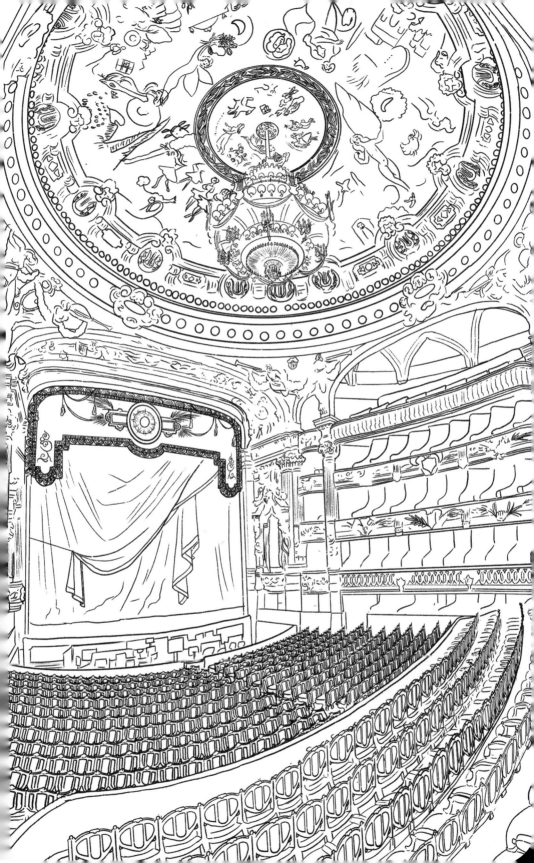

Galeries Lafayette

..

40 Blvd. Haussmann,

75009 Paris, France (and other locations)

Est. 1912

Galeries Lafayette may be a department store, but it is much more than a place to go shopping. The French chain's flagship location on Boulevard Haussmann, which was unveiled in 1912, was designed to be a "luxury bazaar"—a vision that remains today. The boutiques and shops at the Galeries Lafayette are situated beneath a stunning domed roof and Neo-Byzantine–style stained glass windows, and accessed by a staircase inspired by the one at the Palais Garnier. The department store houses more than 3,500 brands, many of them luxury, along with a 32,000-square-foot wellness gallery, a wine cellar, several restaurants and specialty food markets, and even perks like cooking classes and personal shoppers.

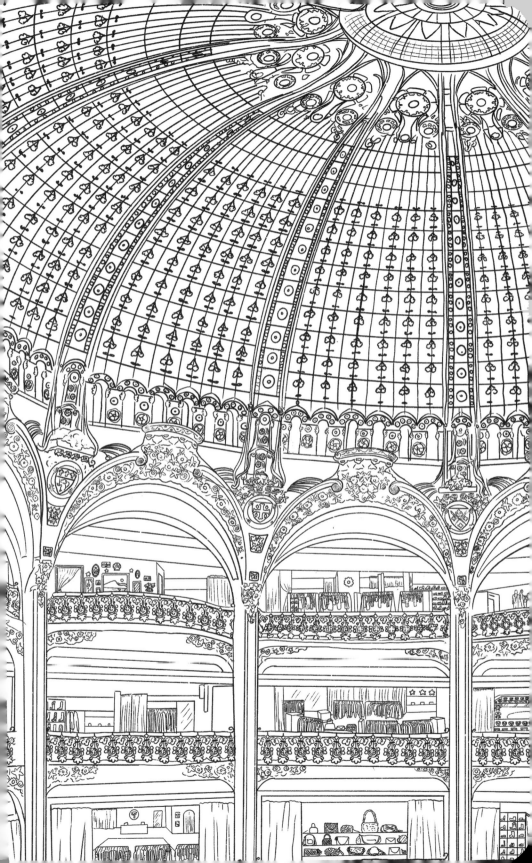

Canal Saint-Martin

..

Begins at Paris Place de Stalingrad
(Bassin de la Villette, Canal de l'Ourcq)
Est. 1825

When it comes to Parisian waterways, the Seine gets all the attention, but the lesser-known Canal Saint-Martin is also an amazing spot to eat, drink, and shop along the water, or to simply go for a walk on the cobblestone pathways surrounding the canal. This local hot spot lives up to the hype, with some of the best eating and shopping in the city—minus the crowds. After work, friends gather along the canal's edge to uncork a bottle of wine and nibble on crêpes to-go, while the adjacent Jardin Villemin provides a rolling green picnic space with an impressive community garden. The top of one of the many bridges that cross the canal provides a bird's-eye view of the idyllic scene.

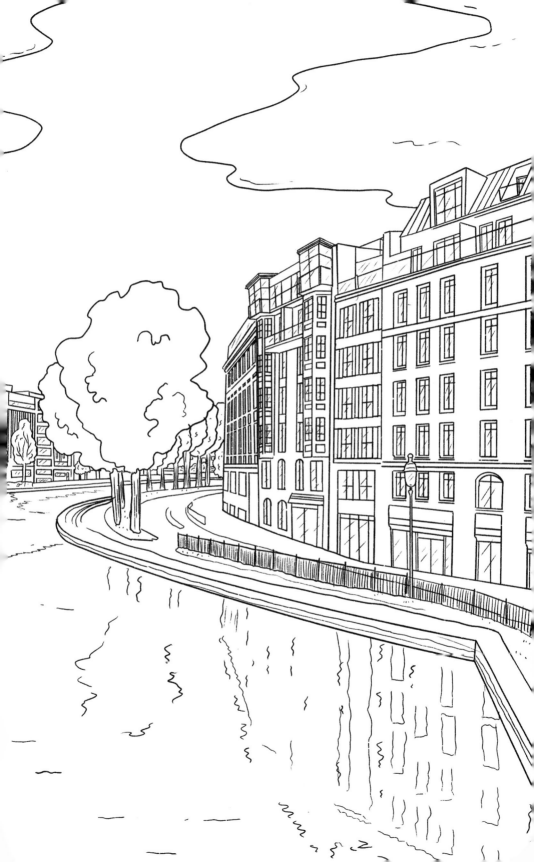

La Coulée Verte René-Dumont

The Greenway of René Dumont

1 Coulée Verte René-Dumont,

75012 Paris, France

Est. 1988

Above the buzz of Paris's 12th arrondissement is La Coulée Verte, a park built on top of an old elevated railway. The greenway, which is also known as the Promenade Plantée, was created in 1988 and runs for almost three miles, connecting the Opéra Bastille with the Bois de Vincennes, a large public park. Along the way, walkers are treated to both wild vegetation and landscaped greenery as the route passes over bustling city streets, through tunnels and buildings, and across the beautiful Jardin de Reuilly, a lovely park. There are inviting benches, flower-covered wrought iron gates, and peaceful water fountains along the way, and horticulturists will find several varieties of lime and hazelnut trees.

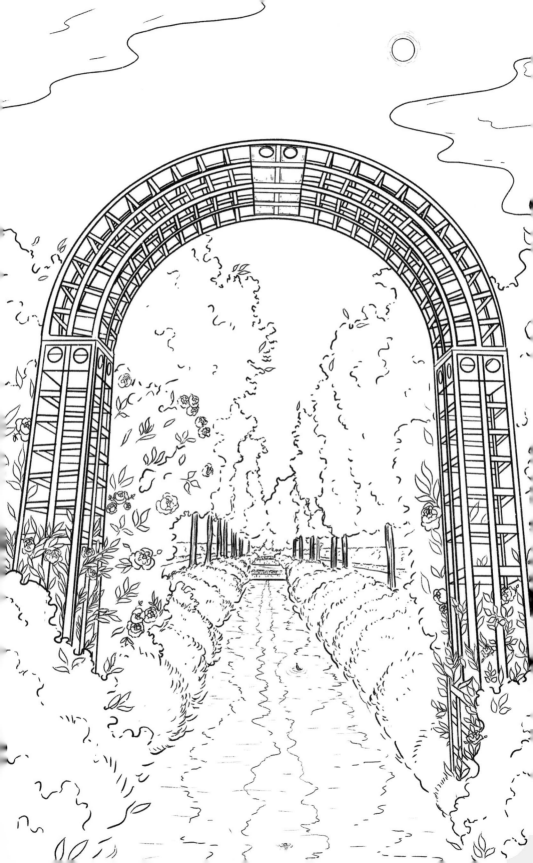

Les Catacombes de Paris

··

The Catacombs of Paris
1 Ave. du Colonel Henri Rol-Tanguy,

75014 Paris, France

Est. 1810

There is perhaps nothing more disturbing—or interesting, depending on your point of view—than realizing that the remains of more than six million people lie below the beautiful streets of Paris. This underground burial ground, known as an ossuary, is accessible to anyone with a ticket. And the journey into this quiet, dark world—a stark contrast to the city's bustling, vibrant energy—starts with a series of stairs that descend over sixty-five feet below the surface of the earth. At the bottom, visitors can walk through underground tunnels lined with the femurs and skulls of millions of Parisians whose bones were relocated when the city's overflowing cemeteries were causing public health problems. The confusing labyrinth has proved difficult and controversial to even fully map out.

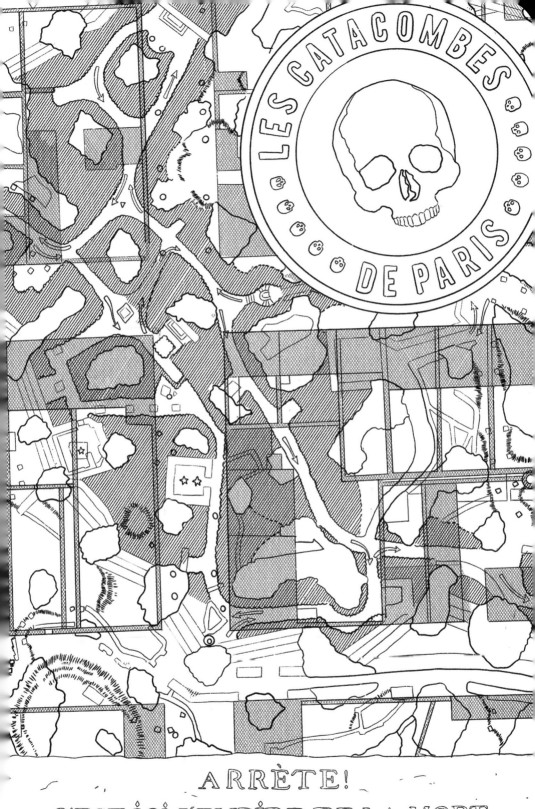

ARRÈTE!
C'EST ÍCÍ L'EMPÍRE DE LA MORT

Frédéric Comyn Boulangerie

88 Rue Cambronne,
75015 Paris, France

The French take their bread—and really all food—quite seriously. The French baguette is listed on UNESCO's Intangible Cultural Heritage list and every year Le Grand Prix de la Baguette determines which bakery makes the best baguette in Paris. Bakers bring their best sample—which must be a certain length and weight—to be judged by a panel who evaluate each qualifying baguette on how well they are cooked and their taste, smell, appearance, and crumb (or texture). Frédéric Comyn Boulangerie's baguette has won in the past, which boosted this bakery's popularity and makes it a wonderful place to pick up a French baguette. The baker, Damien Dedun, has also won a similar award for his croissants.

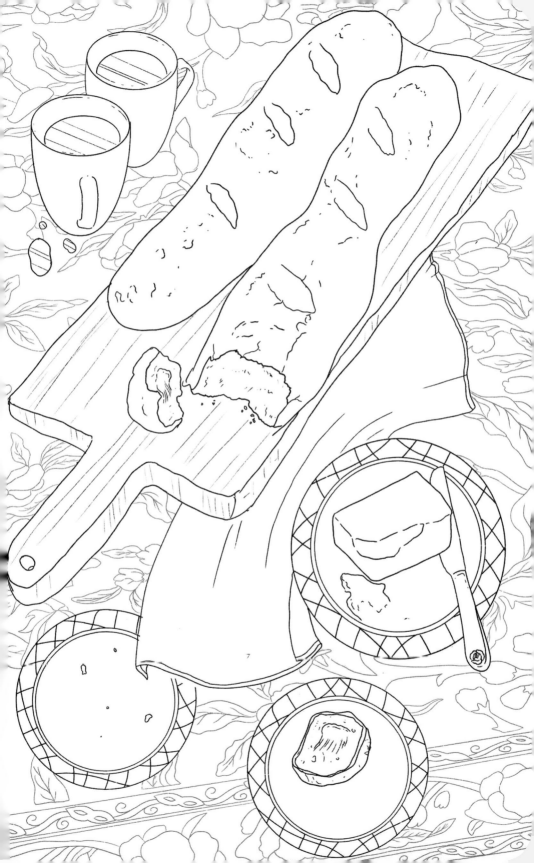

Palais de Tokyo

..

Tokyo Palace

13 Ave. du Président Wilson,

75116 Paris, France

Est. 2002

France may have birthed Impressionist painters like Claude Monet and Pierre-Auguste Renoir, but it also has a soft spot for modern and contemporary art, much of which is housed in the Palais de Tokyo. The museum is Europe's largest center for contemporary creation and rests in the same building as the Musée d'Art Moderne de Paris, another modern and contemporary art museum. The museum features rotating exhibits, many of which have interactive elements, music, and video. The expansive courtyard between the two museums boasts lesser-known views of the Eiffel Tower, as does the Palais de Tokyo's restaurant, Monsieur Bleu.

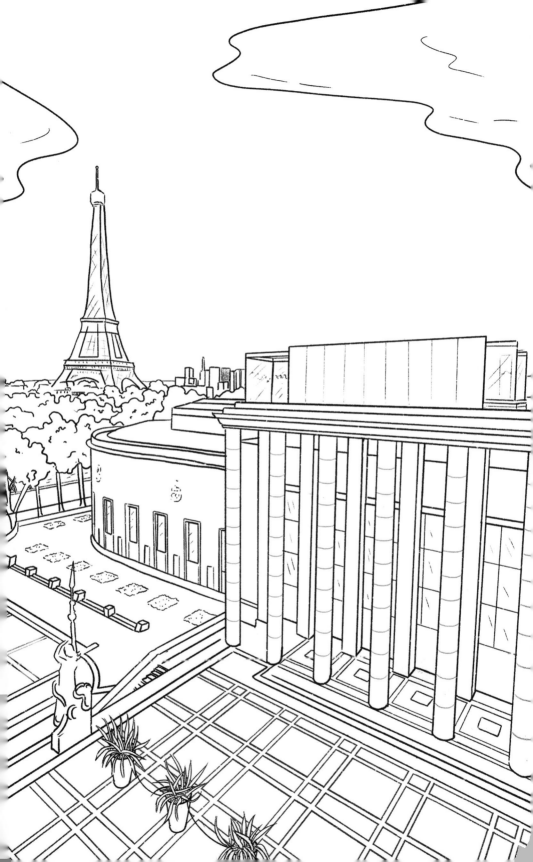

Sacré-Cœur Basilica

··

Basilique du Sacré Cœur de Montmartre (Sacred Heart Church of Montmartre)

35 Rue du Chevalier de la Barre,

75018 Paris, France

Est. 1875

From its perch on a hill in the lovely neighborhood of Montmartre, the Sacré-Cœur Basilica towers over the city. You can see almost the entire city from its vantage point, so visitors tend to perch on the church steps or sprawl out on the steep, grass-covered hill leading up to the basilica. And while the people-watching—with Notre-Dame and the Eiffel Tower in the background—is some of the city's best, travelers spend just as much time looking up at the church's all-white, fairy-tale-like exterior. Entering the church is free, but if you want to walk the three hundred steps to the dome—where the views are even better—you'll need a ticket.

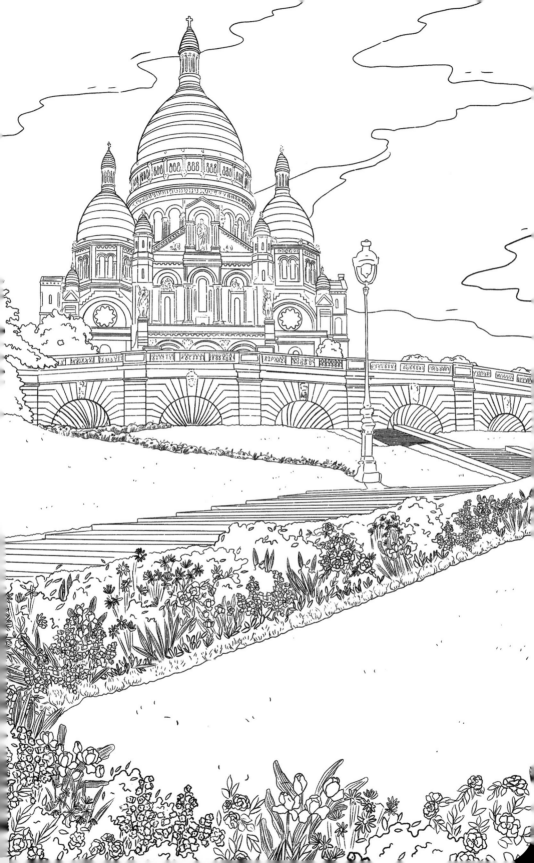

Le Moulin Rouge

Red Mill

82 Bd de Clichy,

75018 Paris, France

Est. 1889

Long before the Moulin Rouge became the name of a movie or a Broadway show, it was a beloved Parisian cabaret. The Moulin Rouge building features a red windmill on its roof that draws people toward what has long been the heart of French entertainment. Established in 1889, the shows continue today, with dozens of artists from all over the world taking the stage—often adorned in sequins, feathers, and rhinestones. The cancan, which was dreamed up and first performed at the Moulin Rouge, continues to be a highlight of the performance. Don't miss a trip up to the Toit, the venue's hidden rooftop terrace, for a preshow drink and tapas.

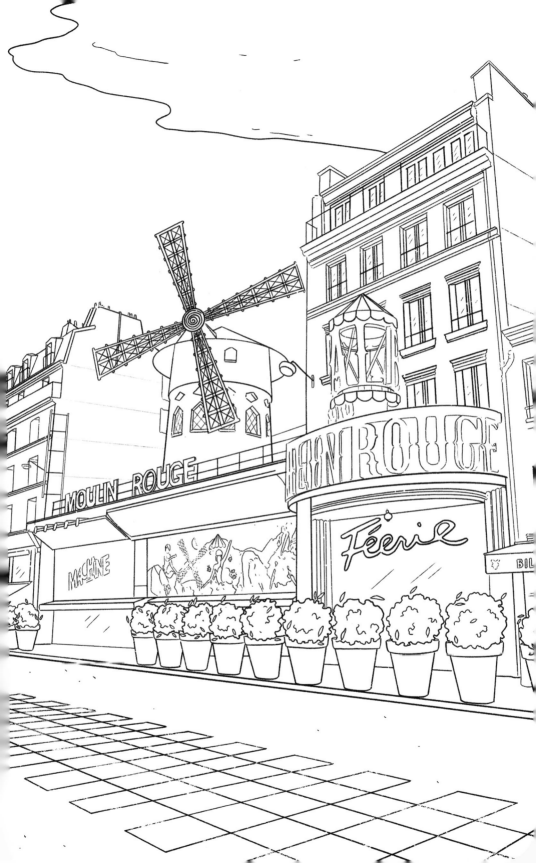

Marché aux Puces de Saint-Ouen

..

Saint Ouen Flea Market

99 All. des Rosiers,

93400 Saint-Ouen-sur-Seine, France

Est. 1885

Just outside the city boundaries is a sprawling network of warehouses and alleyways housing the largest concentration of antique and secondhand dealers in the world. The Marché aux Puces de Saint-Ouen, a true flea market mecca, includes twelve covered markets, five shopping streets, and an endless number of sidewalk merchants. Shoppers can find everything from furniture and paintings to records and vintage clothing among the dizzying streets and walkways. The market dates back to 1870 (though it was officially established in 1885) and continues to be a go-to for bargain hunters and those looking for one-of-a-kind vintage pieces and unusual items.

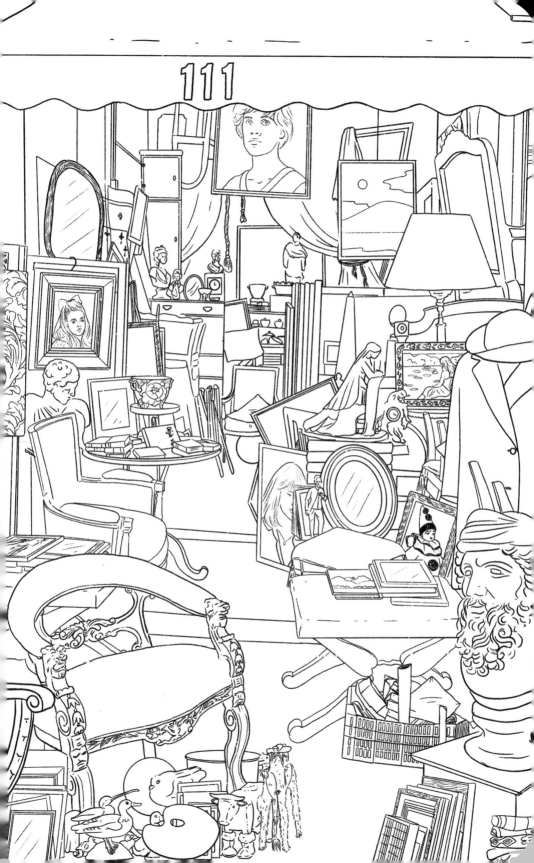

Le Parc des Buttes-Chaumont

Buttes-Chaumont Park

1 Rue Botzaris,

75019 Paris, France

Est. 1867

Le Parc des Buttes-Chaumont doesn't get the foot traffic that the gardens of Tuileries or Luxembourg see, which is what makes this spot such a special find. It is one of the city's largest and most natural parks, occupying more than sixty acres of hilly space in northeastern Paris. The park was built on former quarries, which creates a charming, hilly landscape that's crisscrossed with pathways. There's a suspended bridge, caves and waterfalls, and a temple perched on a 160-foot cliff surrounded by water. It's one of the best places in Paris to read on the grass or gather with friends for a picnic with city views.

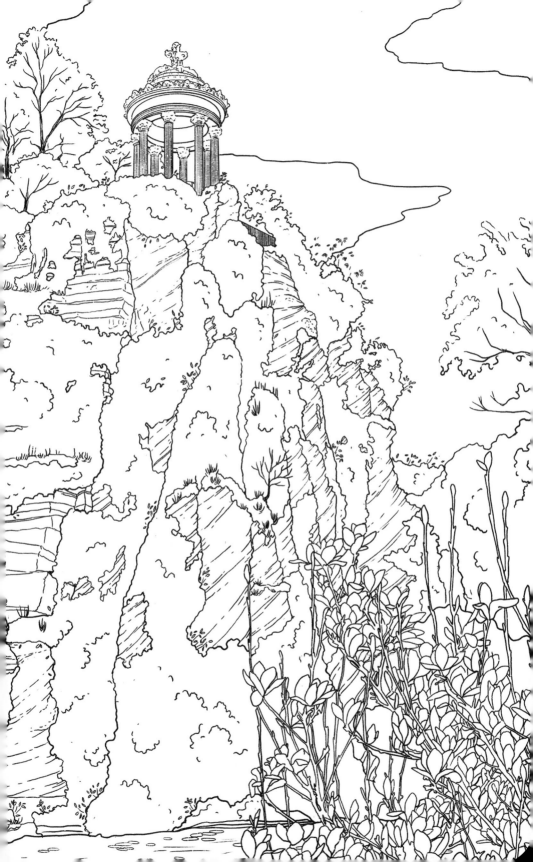

Cimetière du Père-Lachaise

..

Père Lachaise Cemetery

Face au 21 Blvd. de Ménilmontant,

75020 Paris, France

Est. 1804

The chance to pay their respects at the burial place of greats like Jim Morrison, Edith Piaf, and Oscar Wilde may be what first draws visitors to the Cimetière du Père-Lachaise, but people also come to appreciate the cobblestone pathways and quiet, shaded benches. It's not uncommon to see a Parisian reading a book on a bench during their lunch break or a couple strolling among ancient, moss-covered mausoleums. The cemetery is both an elegant final resting place and a welcome respite from the busy city—it's no wonder it is considered the most prestigious and most visited necropolis in the world.

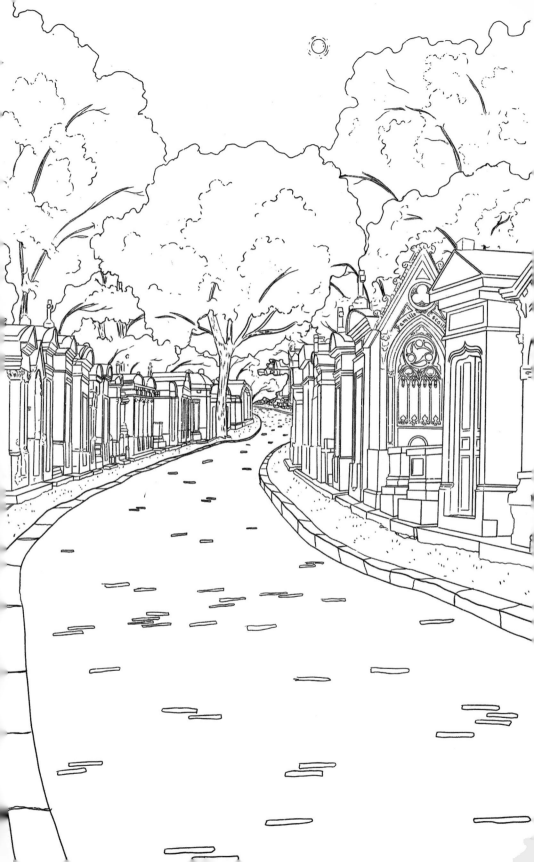

Rue Denoyez

Denoyez Street

Rue Denoyez,
75020 Paris, France

Street art abounds in Paris, but every artist wants to make their mark on Rue Denoyez, a quiet pedestrian street in Belleville, one of the city's Chinatown neighborhoods. The cobblestoned Rue Denoyez is lined with graffiti and art installations that provide endless discovery—you never know how the art will evolve from one day to the next. (In the coloring page here, you can add your own creative contributions to the area!) Besides the eclectic art, this street also houses Le Petit Grain (where arguably the best cinnamon buns in the city are made) and Le Barbouquin, an eclectic, book-lined restaurant and coffee shop that feels like a natural extension of the graffiti-covered street.

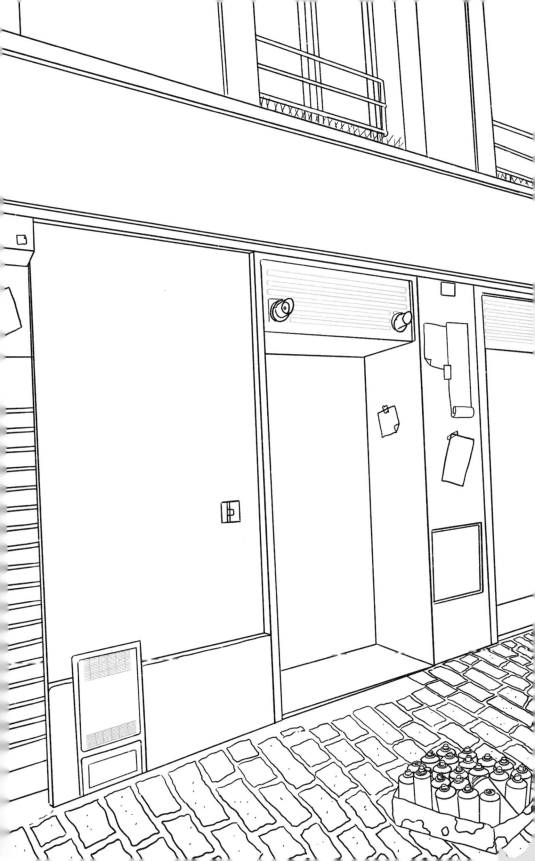

Château de Versailles

···

Palace of Versailles

Place d'Armes,

78000 Versailles, France

Est. 1661

Just outside Paris in the commune of Versailles is a proper French palace straight out of a fairy tale. The interiors boast gilded rooms and giant chandeliers, and the grounds feature almost two thousand acres of perfectly manicured gardens and green space. This opulent royal residence once housed the likes of King Louis XIV, Napoleon Bonaparte, and Marie-Antoinette, and continues to welcome people from all over the world. The palace and its auxiliary buildings and gardens also act as a museum of sorts, housing around sixty thousand works of art. The palace and gardens are truly exquisite, but not many know about the Petit Trianon, Marie-Antoinette's estate, which is also on the grounds. Her bedroom features unique mirrored panels that can be raised or lowered to properly reflect the light or cover the windows to ensure privacy.

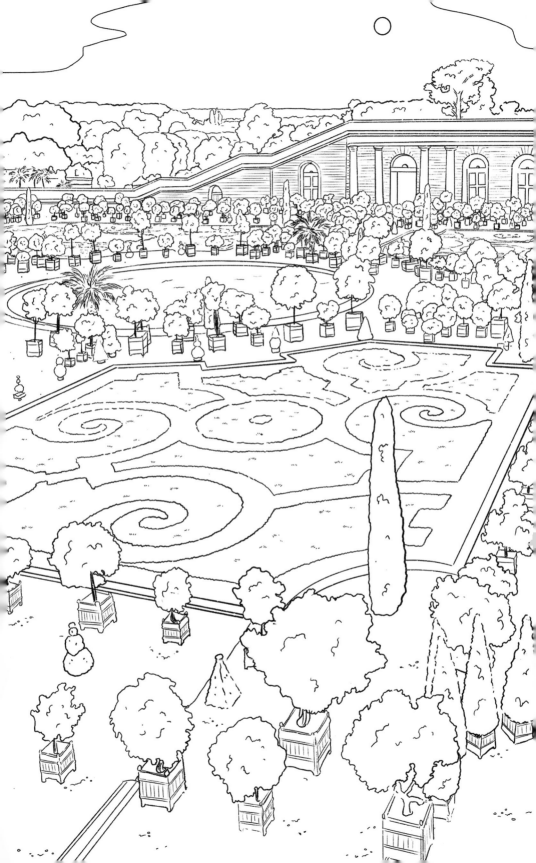

About the Author

Evie is a writer and editor who's lived in five countries and visited well over fifty. These days, she splits her time between a small town in Colorado and Paris, France, a city she reluctantly fell in love with and now can't get enough of. When she's not playing in the Rocky Mountains or croissant-tasting on the streets of Paris, you'll find her dreaming up her next adventure with her husband and daughter.

Grab Your Pen and Colored Pencils—and Travel the World!

PICK UP YOUR COPIES TODAY!